Medieval Alphabets and Decorative Devices

Edited by
Henry Shaw

DOVER PUBLICATIONS, INC.
Mineola, New York

Bibliographical Note

This Dover edition, first published in 1999, is a new selection of plates from *Alphabets, Numerals, and Devices of the Middle Ages*, originally published by William Pickering, London, in 1845, and *The Handbook of Mediaeval Alphabets and Devices*, originally published by Bernard Quaritch, London, in 1853.

DOVER *Pictorial Archive* SERIES

Library of Congress Cataloging-in-Publication Data

Shaw, Henry, 1800–1873.
 [Alphabets, numerals, and devices of the Middle Ages]
 Medieval alphabets and decorative devices / edited by Henry Shaw.
 p. cm. — (Dover design library) (Dover pictorial archive series)
 Originally published: Alphabets, numerals, and devices of the Middle Ages. London : William Pickering, 1845.
 ISBN 0-486-40466-8 (pbk.)
 1. Alphabets. 2. Numerals. 3. Illumination of books and manuscripts, Medieval. I. Title. II. Series. III. Series: Dover pictorial archive series.
NK3610.S5 1999
745.6'094'0902—dc21 99-10030
 CIP

Manufactured in the United States of America
Dover Publications, Inc., 31 East 2nd Street, Mineola, N.Y. 11501

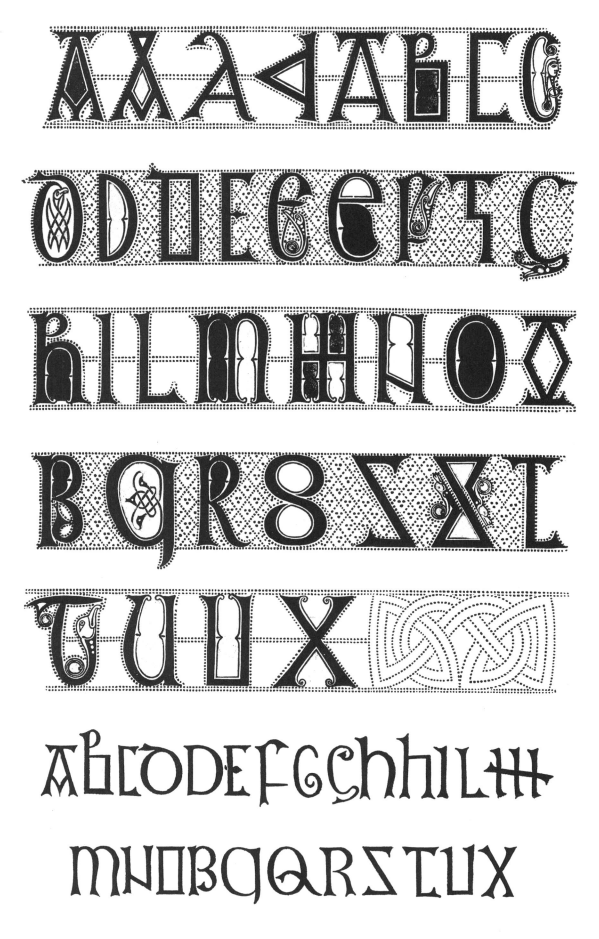

From a copy of St. Cuthbert's Gospels in the British Museum, early 8th century.

1

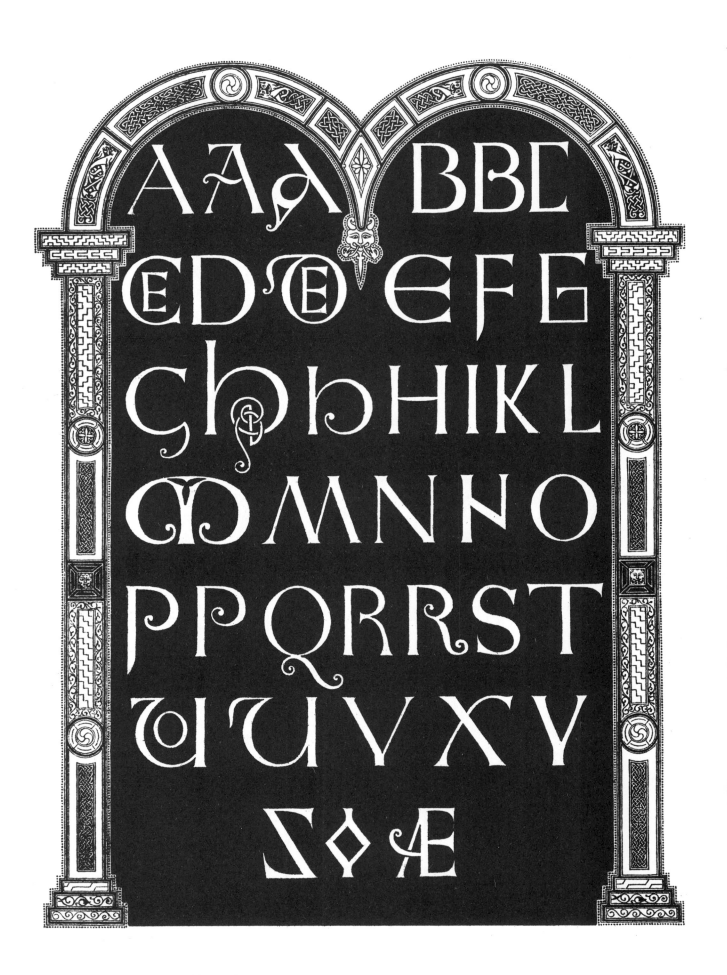

From the British Museum, Royal MS., 10th century.

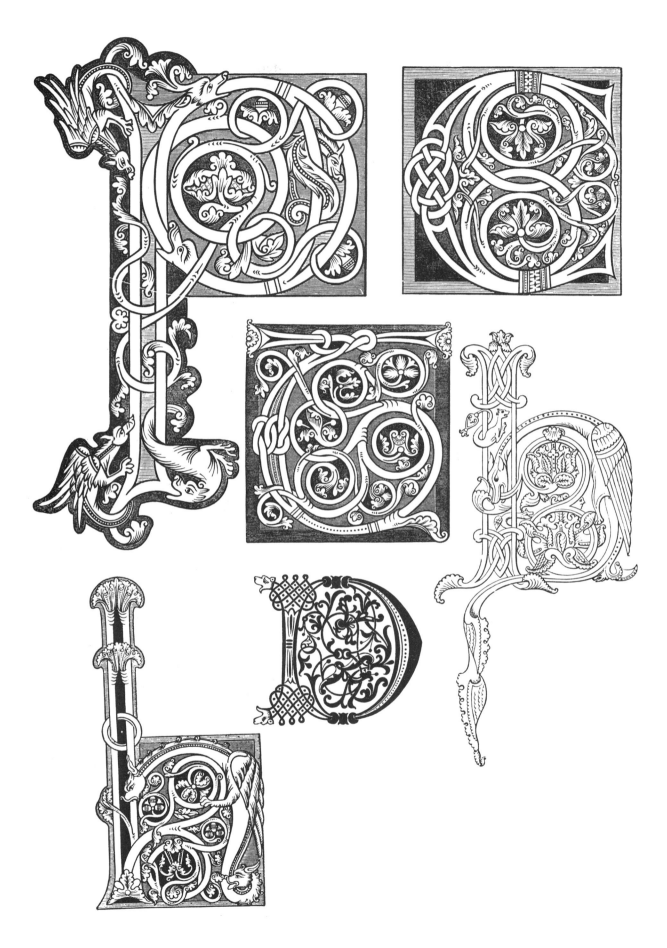

From a copy of the Works of Josephus and other MSS., 12th century.

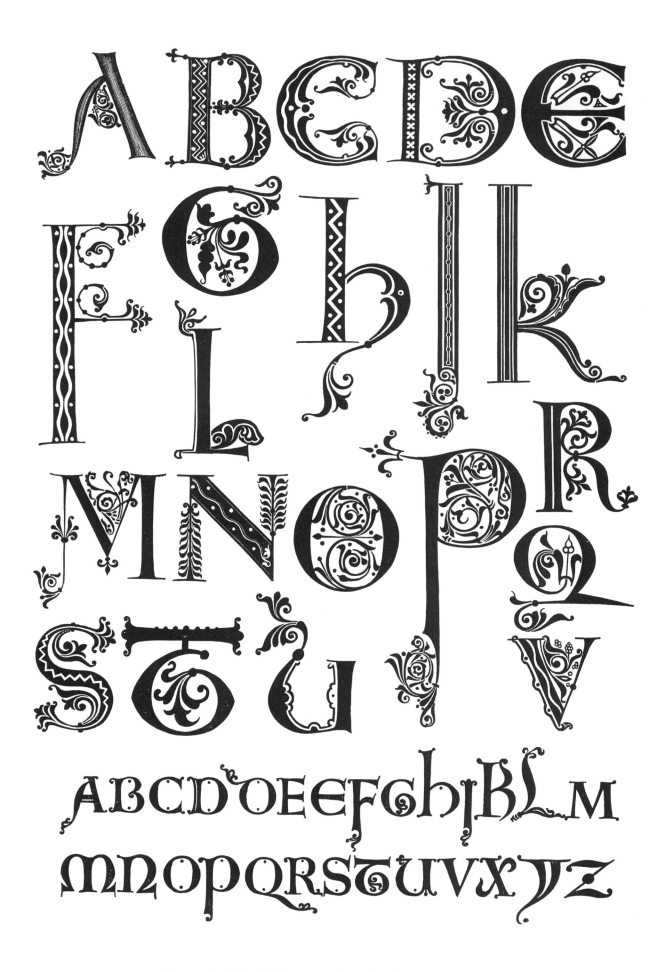

From the British Museum, Royal MS., 12th century.

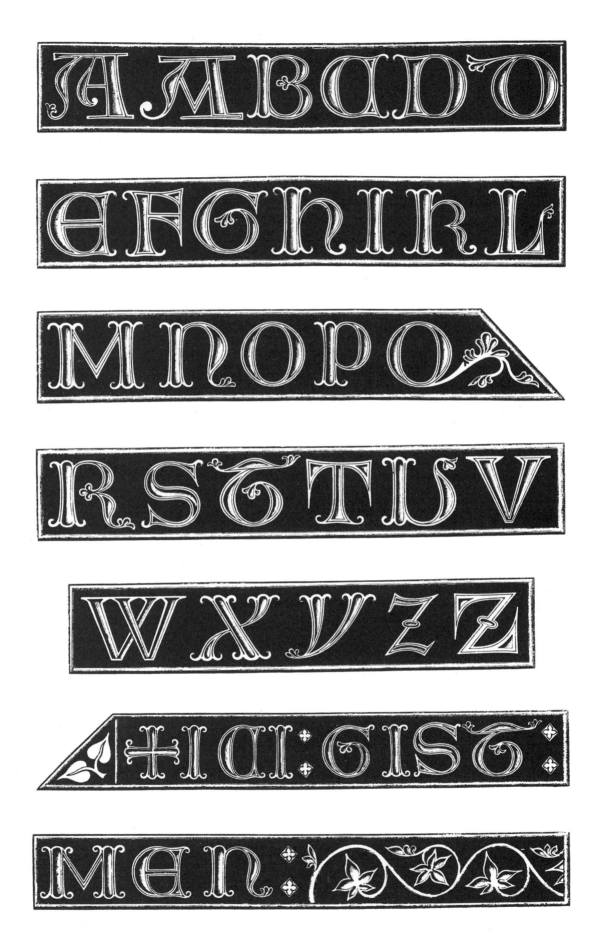

Letters in bronze, from the monument of Henry III
in Westminster Abbey, 1272.

ABCDE
FGHIJK
LMNOP
QRSTV
WXYZ

✠ ANNO · DOMINI ·

From a brass at the Cathedral at Lubeck, 1341.

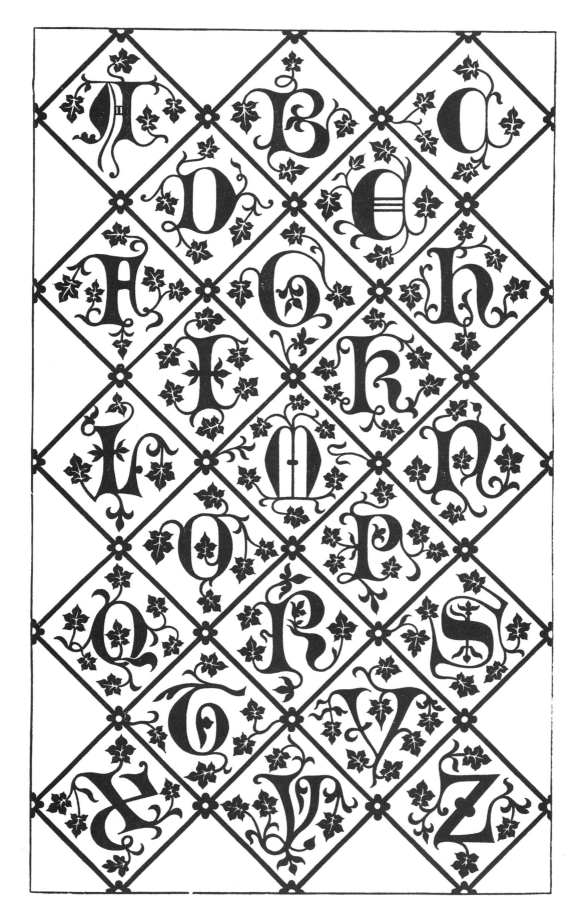

From an embroidered altar cloth, in the Church of St. Mary,
at Soest, in Westphalia, 14th century.

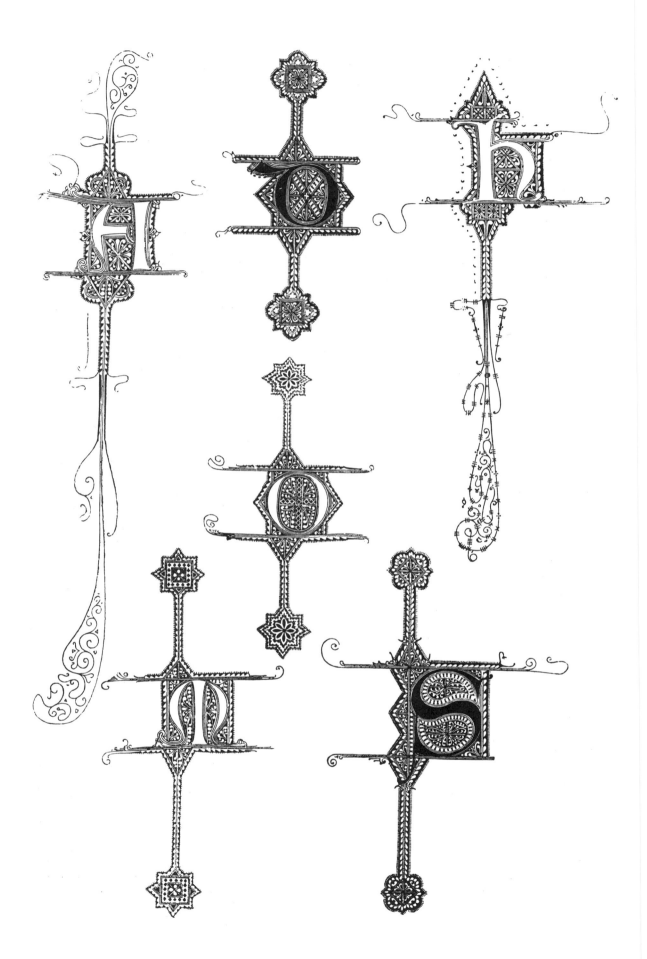

From the British Museum, Royal MS., no date.

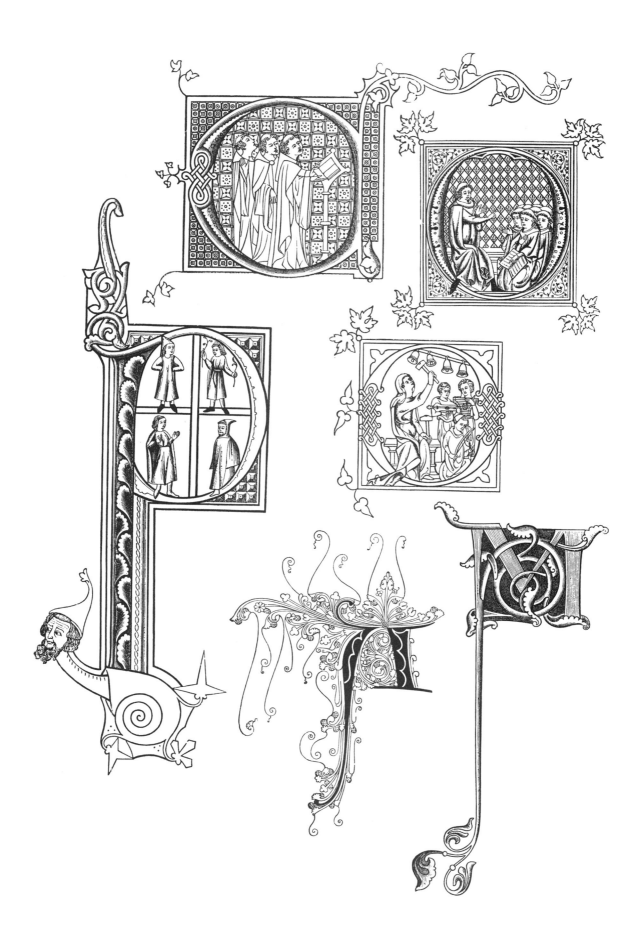

From various illuminated manuscripts, 14th century.

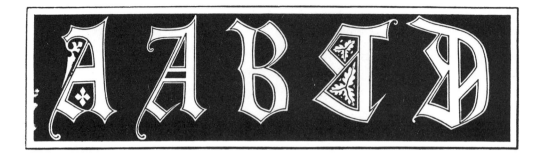

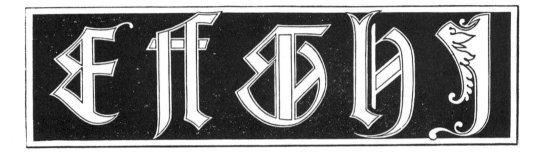

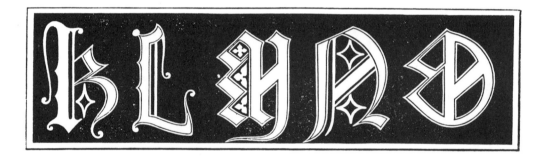

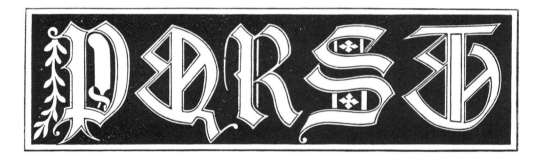

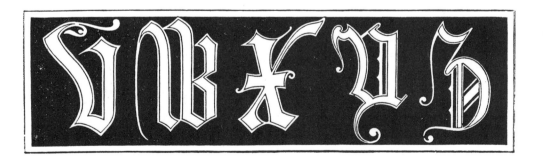

10 From the monument of Richard II in Westminster Abbey, 1400.

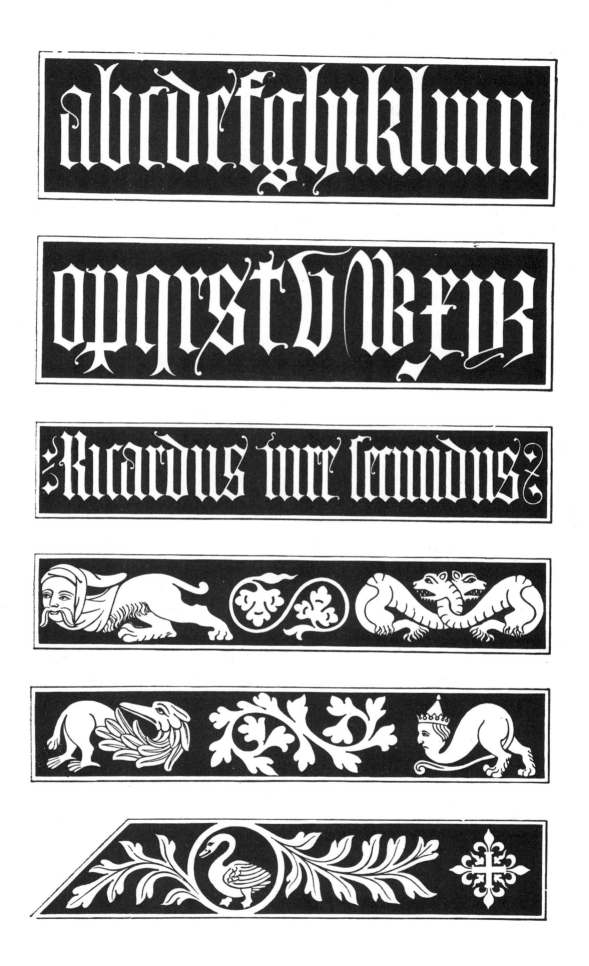

From the monument of Richard II in Westminster Abbey, 1400.

11

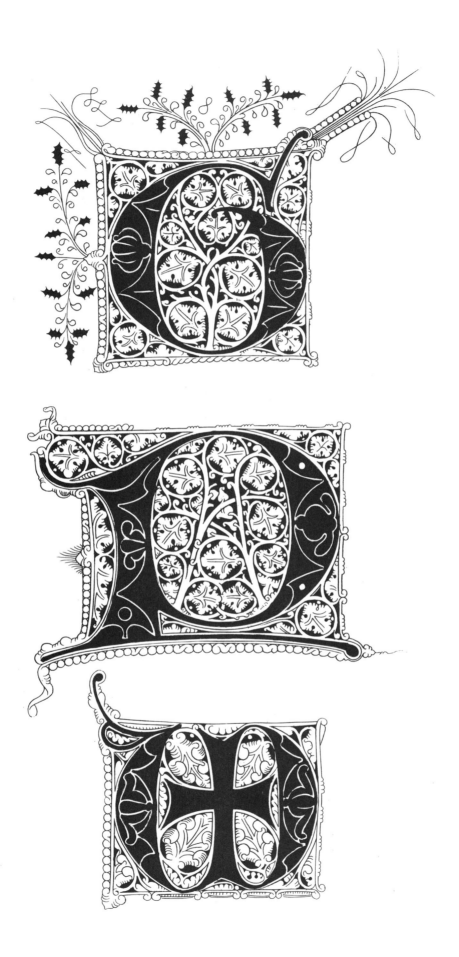

12 From a Missal of the Rev. W. Maskell, 1470.

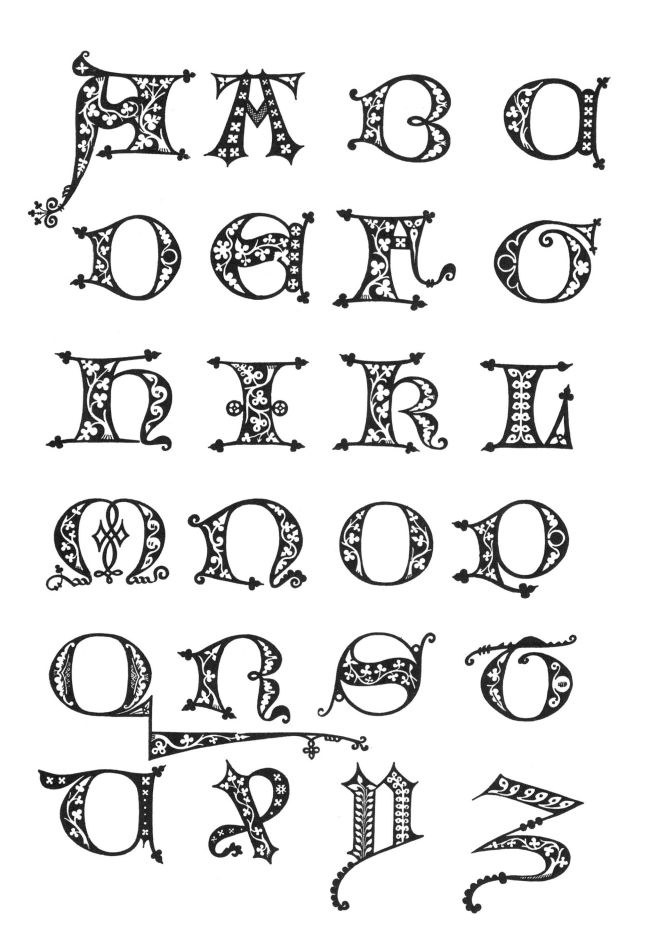

From Summa Bartholomæi Pisani Ord. Prædic. de Casibus Conscientiæ, 1475.

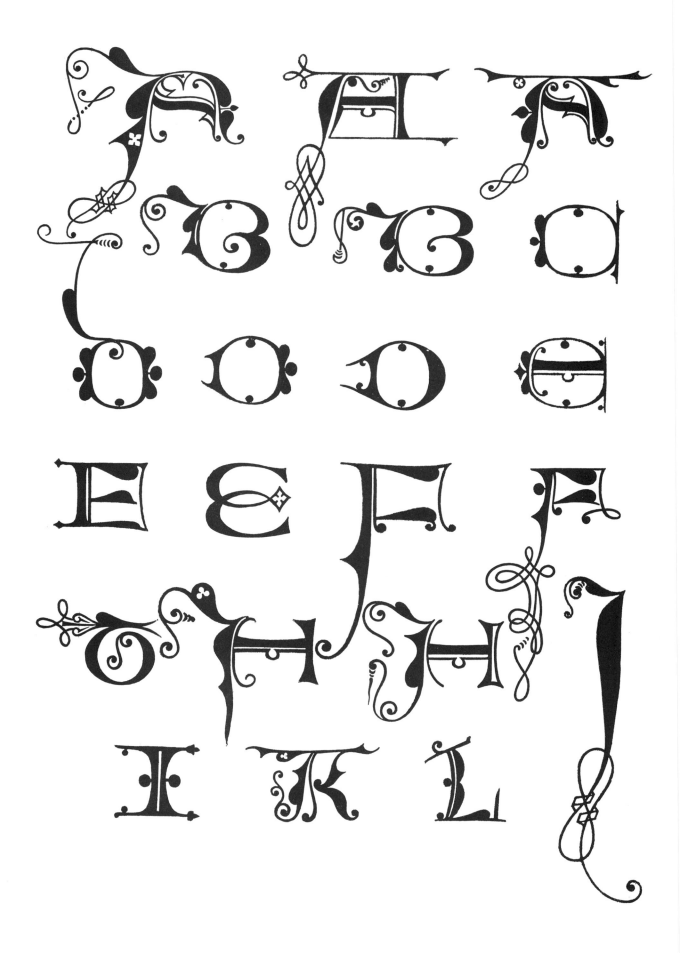

14 From a Pontificale of John II Archbishop of Treves, 1480.

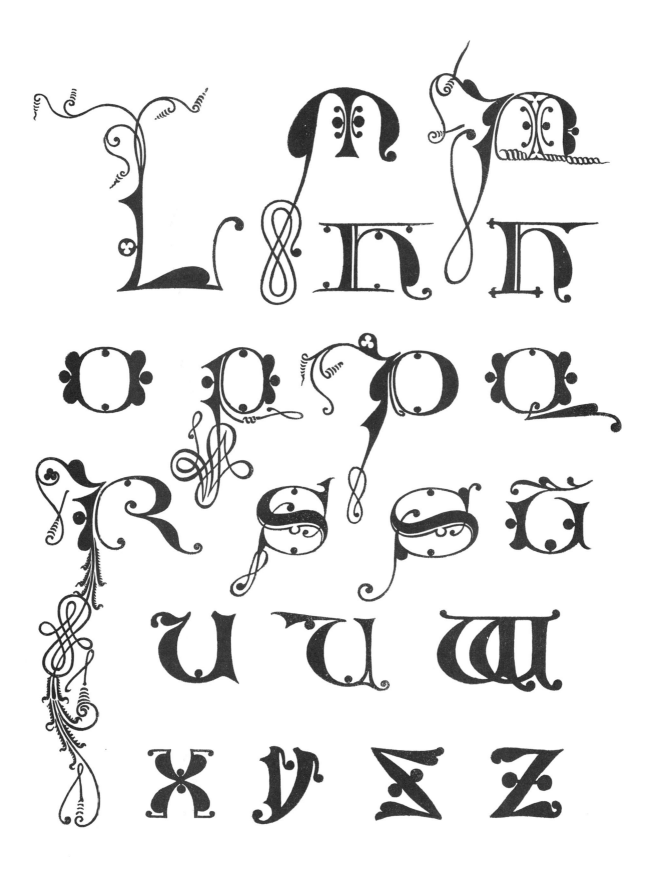

From a Pontificale of John II Archbishop of Treves, 1480.

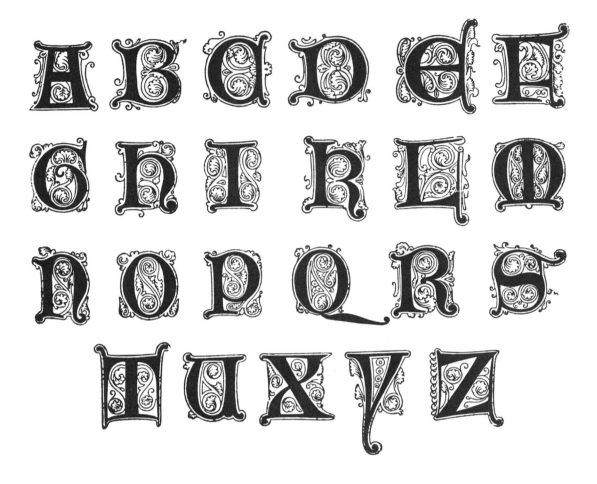

TOP: From a MS. at Rouen, 1480.
BOTTOM: From a Benedictionale of the Rev. W. Maskell, 1480.

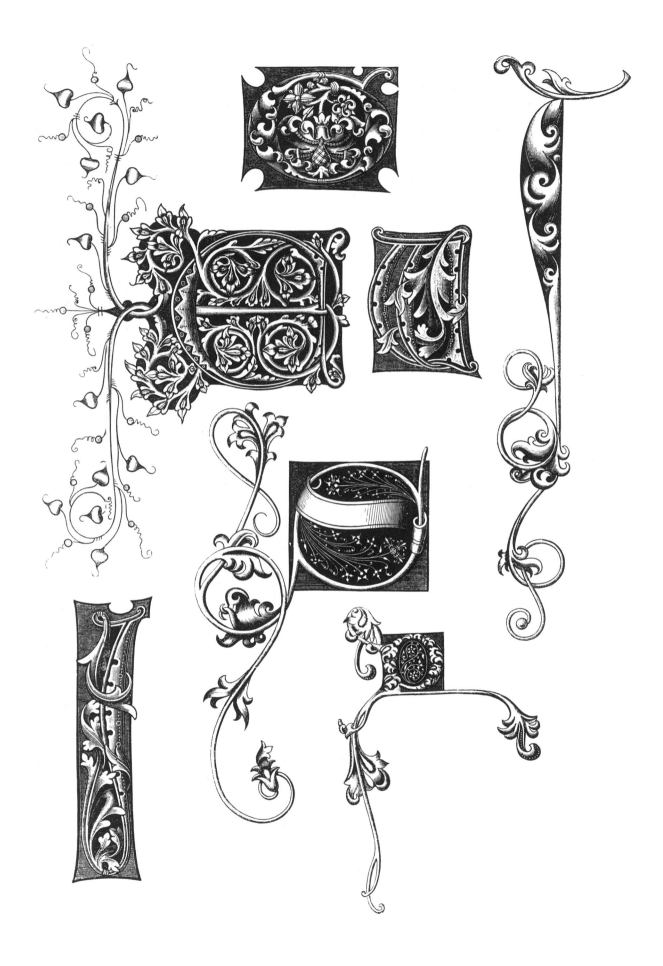

From Fust and Schoeffer's Bible, 15th century.

17

From a volume entitled *Preservation of Body, Soul, Honor, and Goods,* 1489.

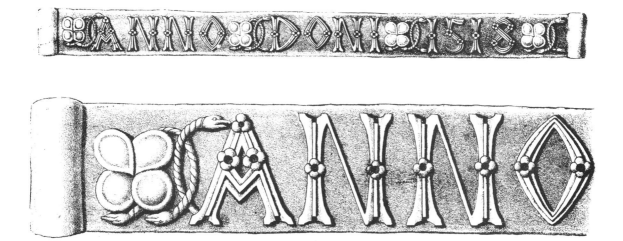

TOP: From a volume entitled *Preservation of Body, Soul, Honor, and Goods,* 1489.
BOTTOM: From a gateway in Chancery Lane, 1518.

19

From a copy of the Sforziada in the British Museum, 1490.

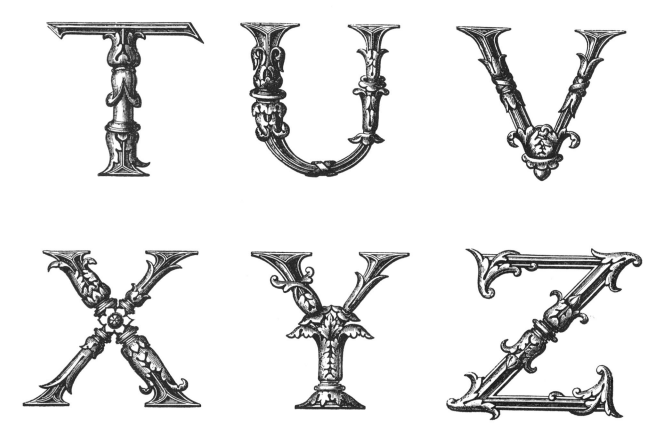

From a copy of the Sforziada in the British Museum, 1490.

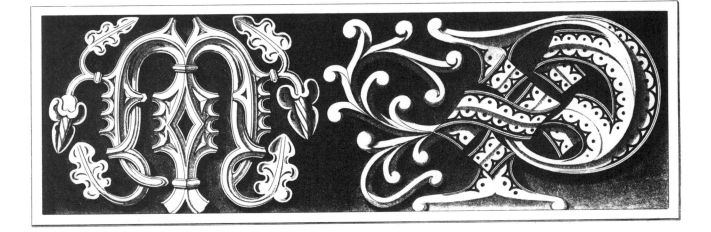

From the stalls of St. George's Chapel, Windsor, late 15th century.

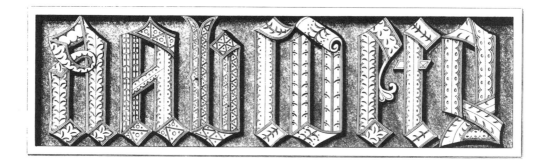

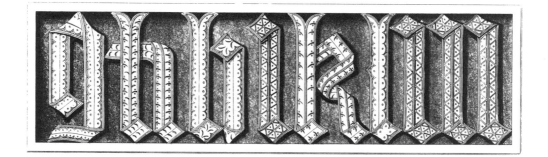

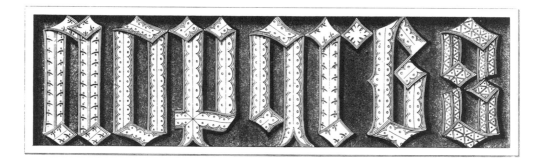

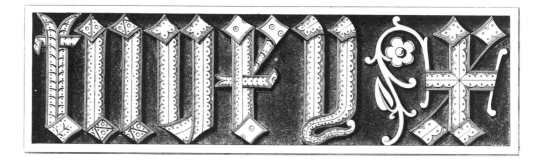

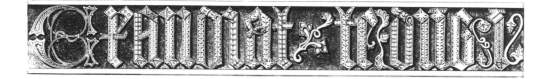

From the stalls of St. George's Chapel, Windsor, late 15th century. 23

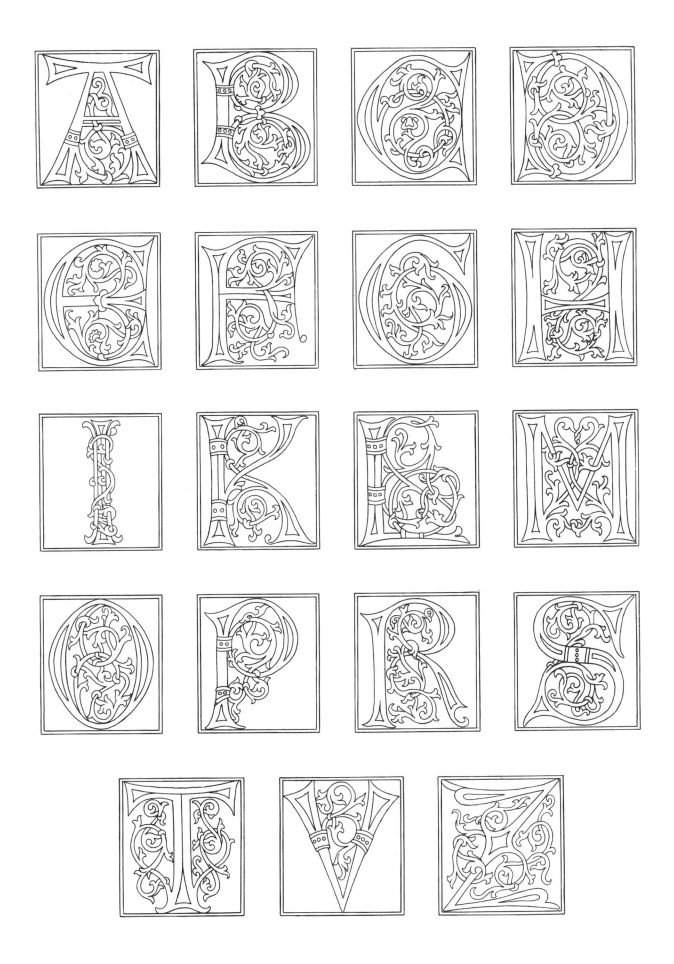

From the Golden Bible, late 15th century.

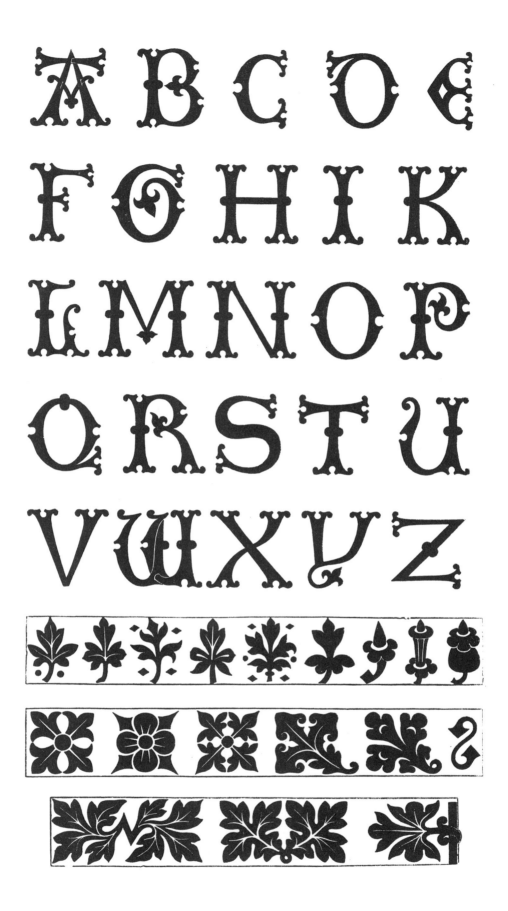

From Westminster Abbey, 15th–16th centuries.

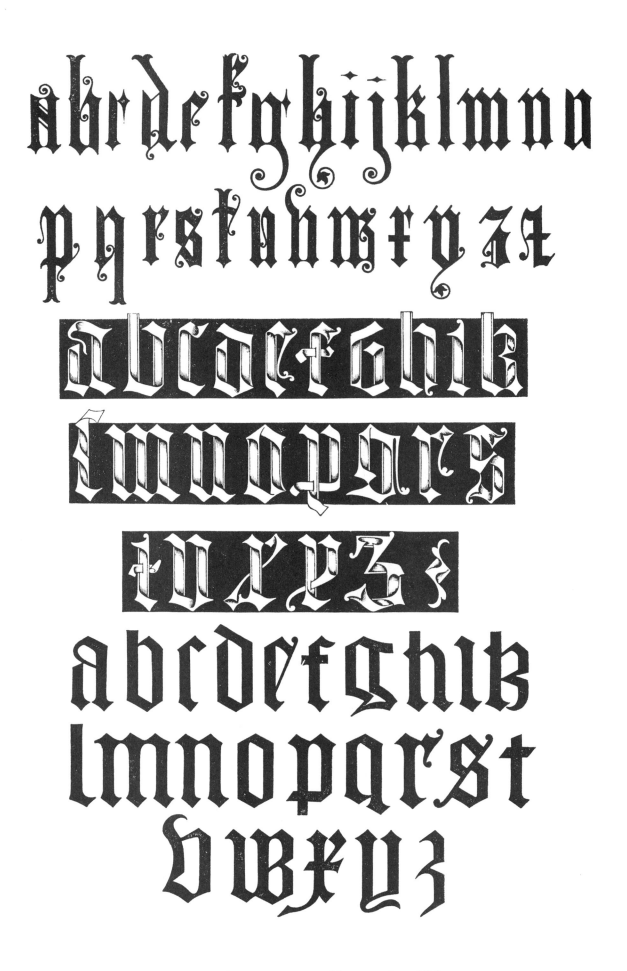

Three alphabets from monumental brasses, late 15th century.

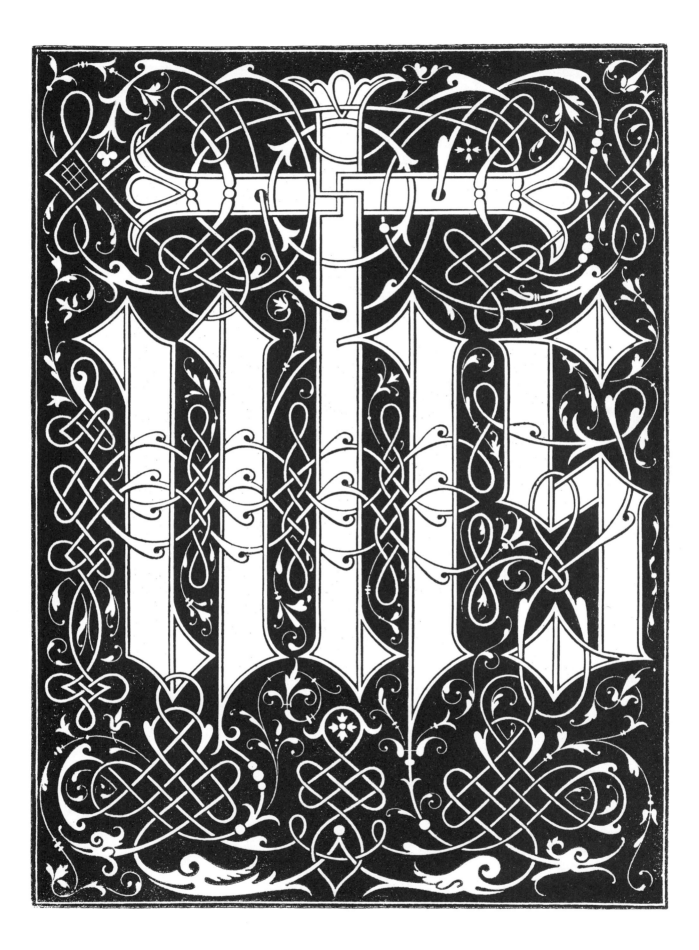

The sacred monogram, from an engraving on wood, early 16th century. 27

 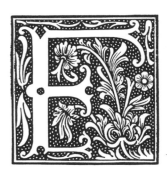

 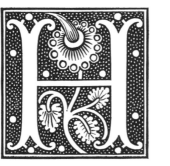 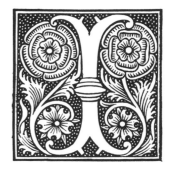

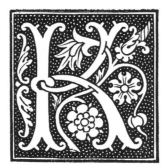

From a copy of the Romant de la Rose, early 16th century.

From a copy of the Romant de la Rose, early 16th century.

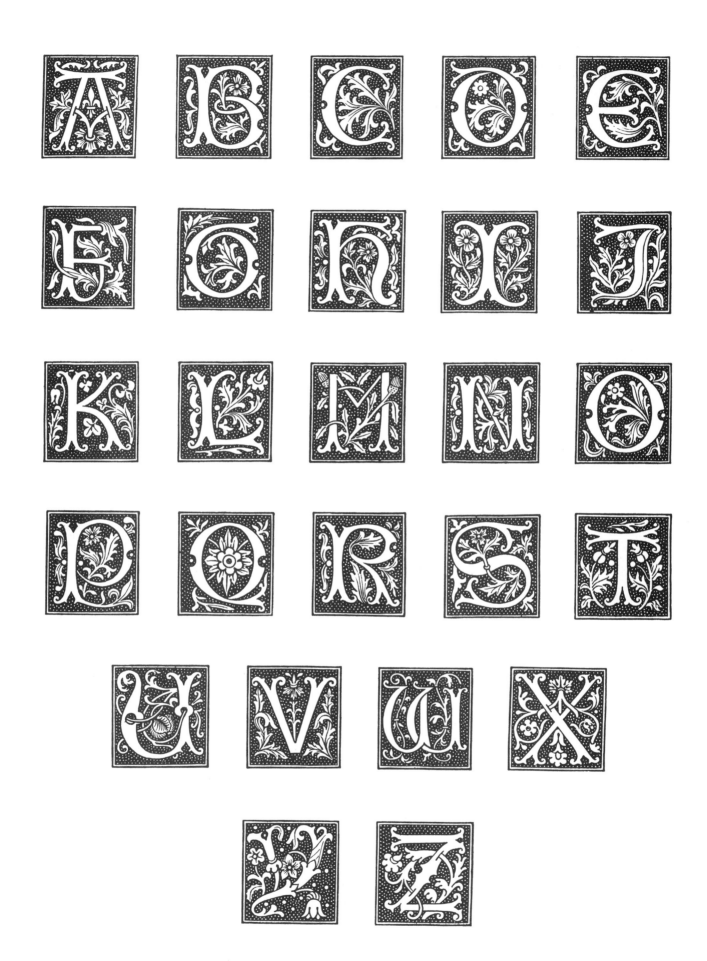

From woodcuts in various printed books, early 16th century.

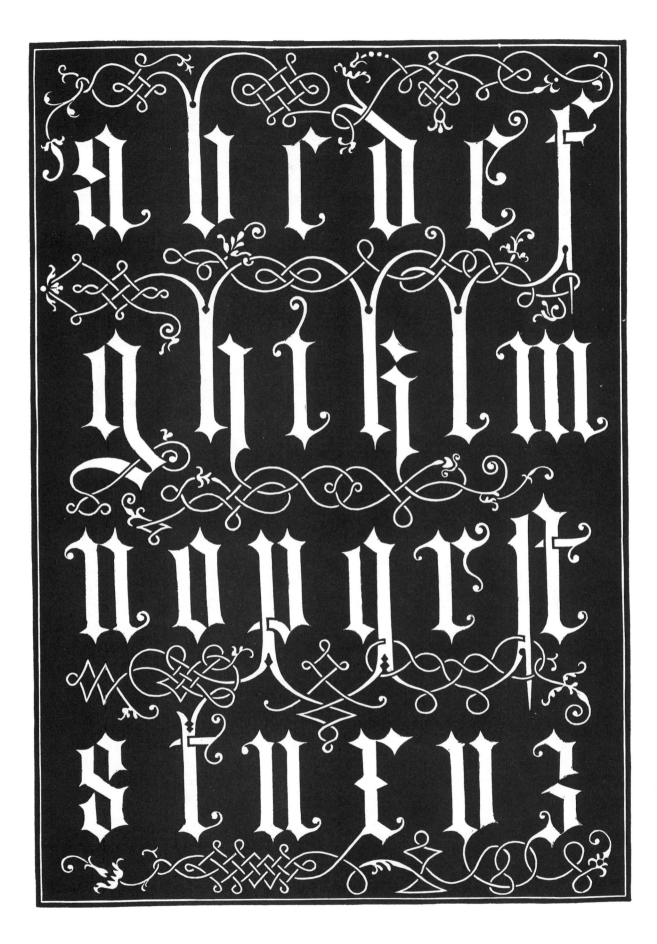

From an engraving on wood, early 16th century.

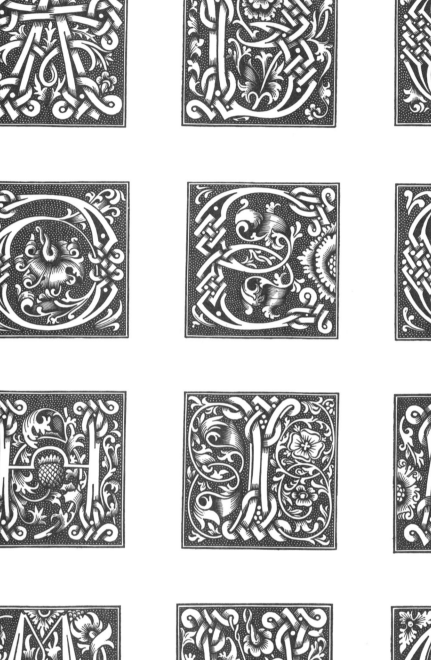

From the Missale Traijectense, 1515.

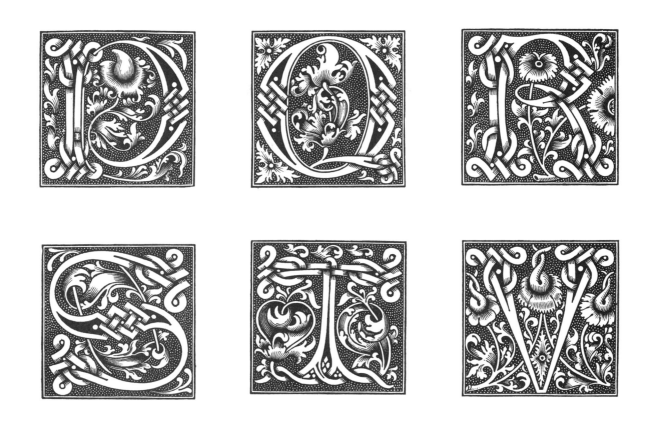

TOP: From the Missale Traijectense, 1515.
BOTTOM: Alphabets, late 15th century.

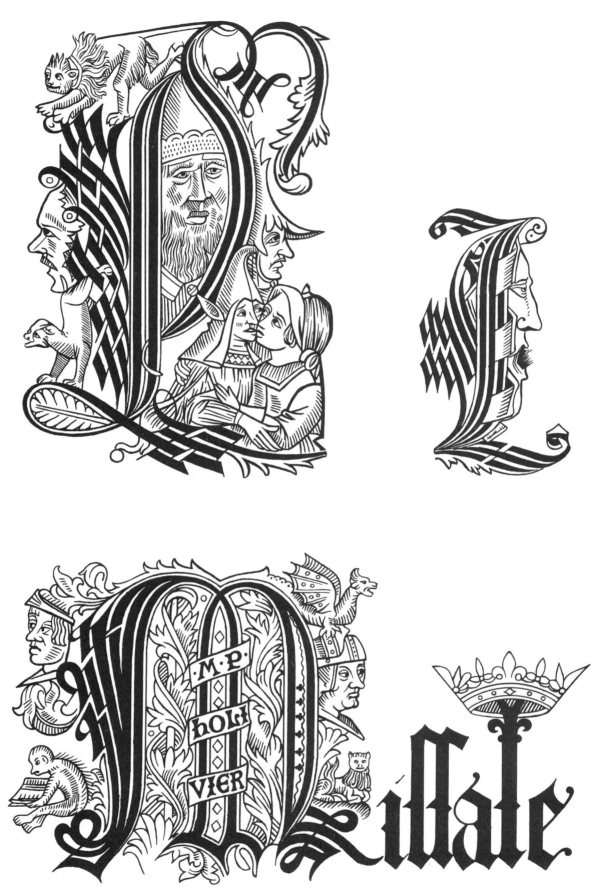

TOP, LEFT: From Lancelot du Lac, 1515. TOP, RIGHT: From Luis de Escobar,
Las Quatro Cientas del Almirante, 1550.
BOTTOM: From Missale Eboracensis Ecclesiæ, 1516.

From the Hystoire de Perceval le Galloys, 1530.

35

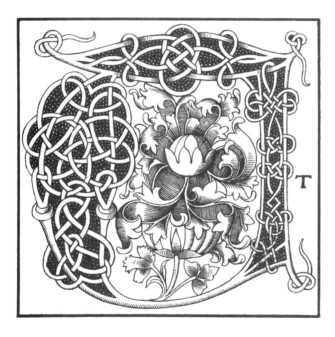

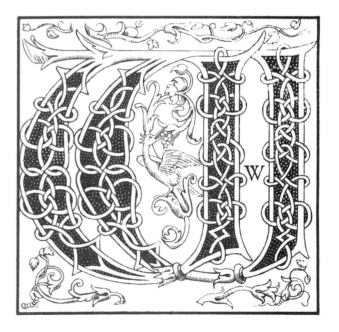

From Cranmer's Bible, 1539.

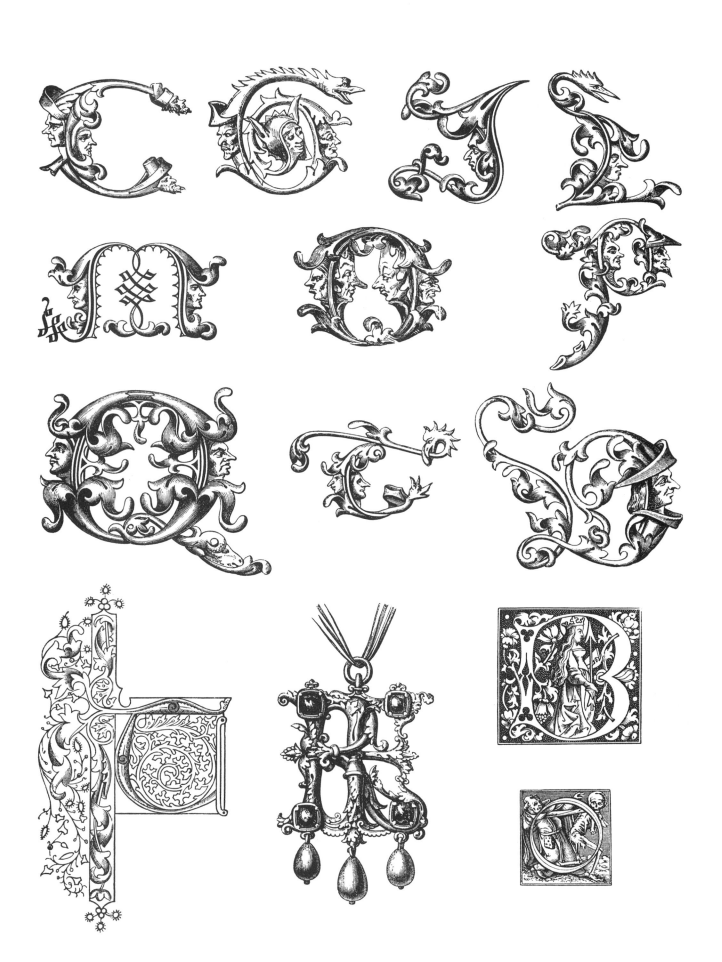

Miscellaneous letters from early printed books and drawings,
15th–16th centuries.

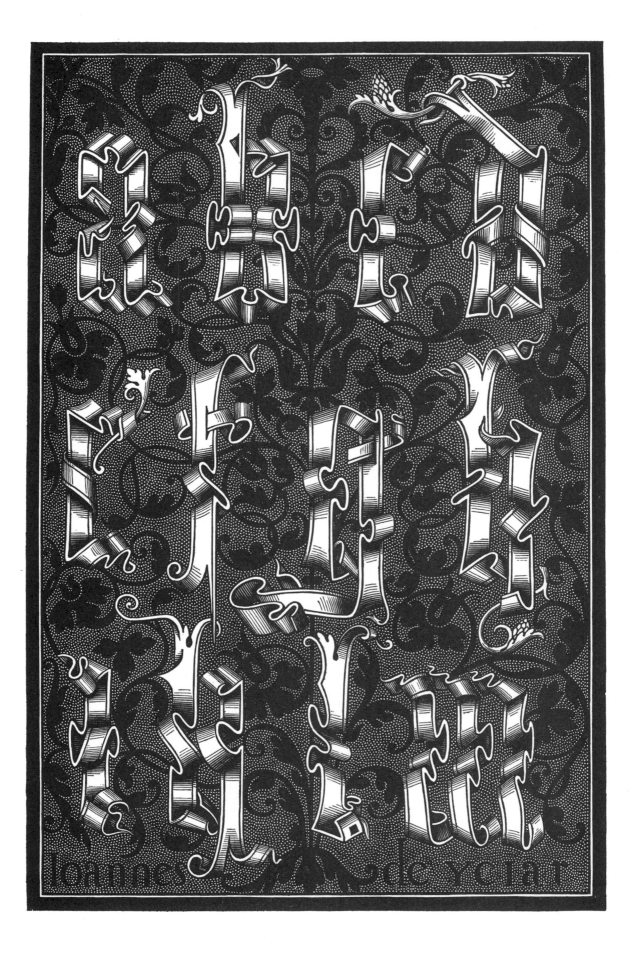

Riband letters, from a volume entitled *Orthographia practica*, 1547.

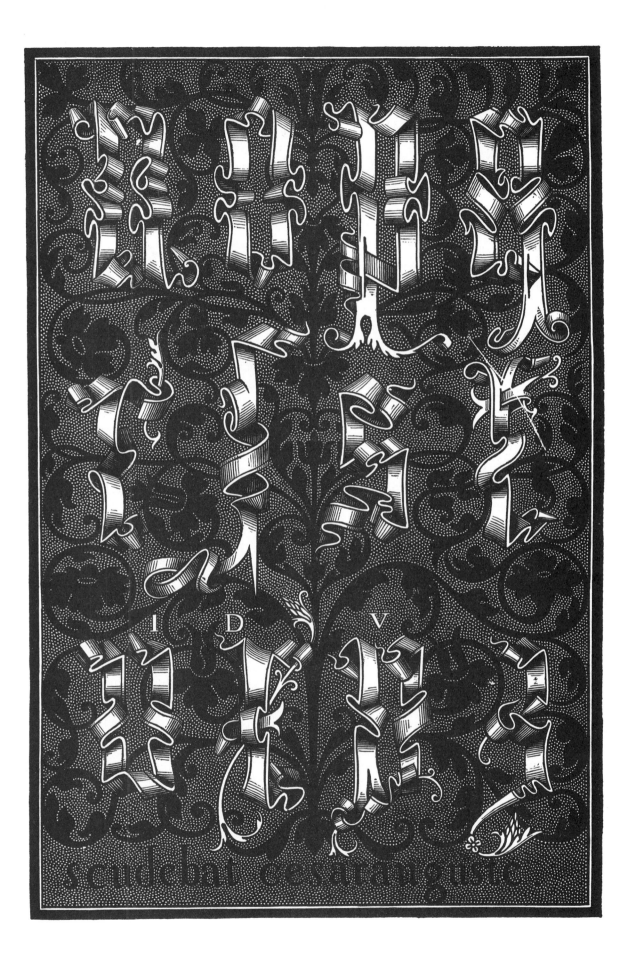

Riband letters, from a volume entitled *Orthographia practica*, 1547.

Branch and riband letters, 16th century.

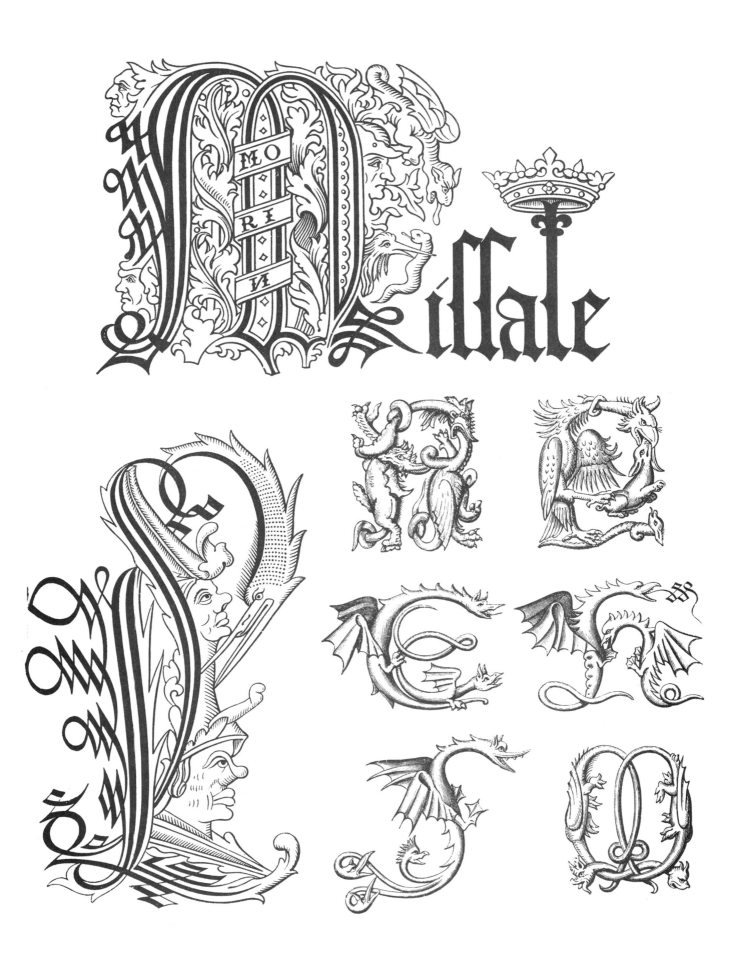

Grotesque letters, from early printed books, 16th century.

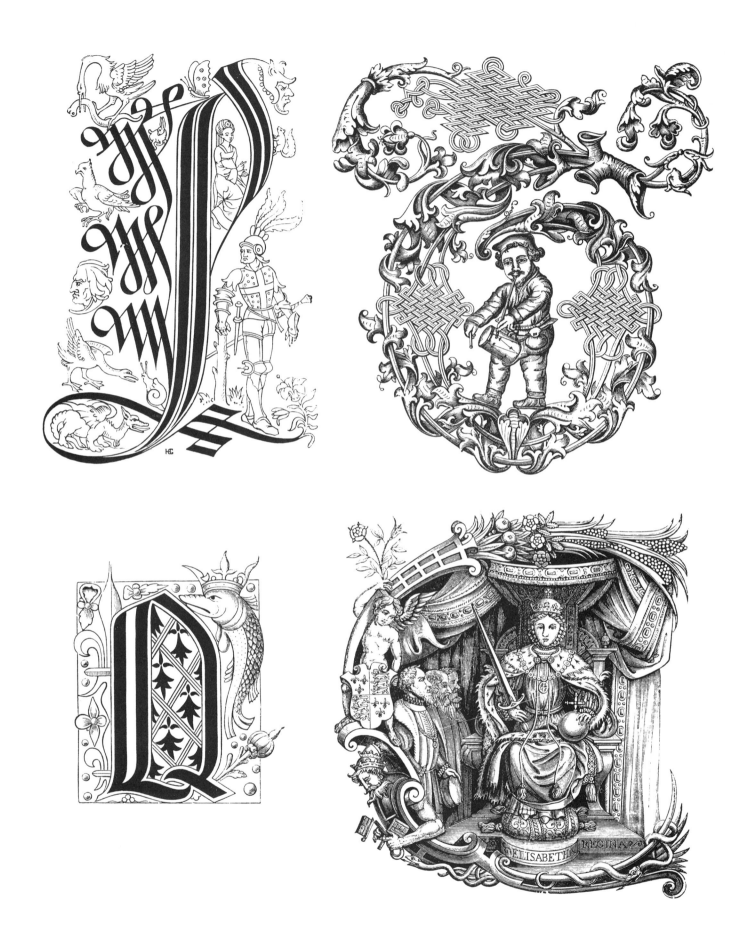

TOP, RIGHT: From a drawing in the British Museum, 15th–16th centuries.
ALL OTHERS: Facsimiles of early engravings on wood, 15th–16th centuries.

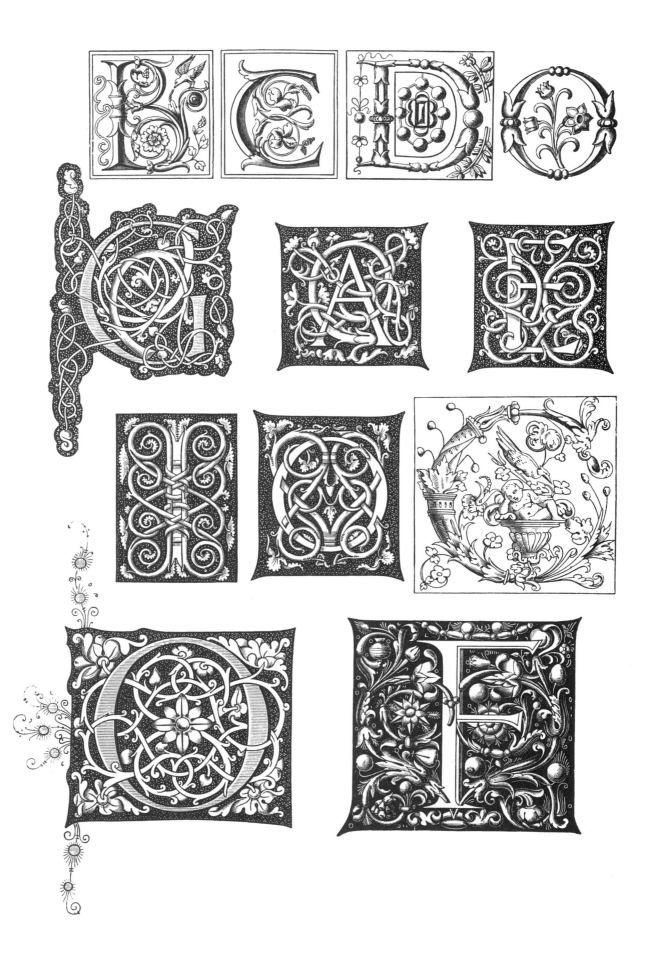

From Italian illuminations, 16th century.

43

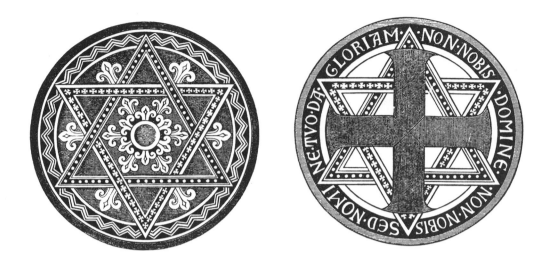

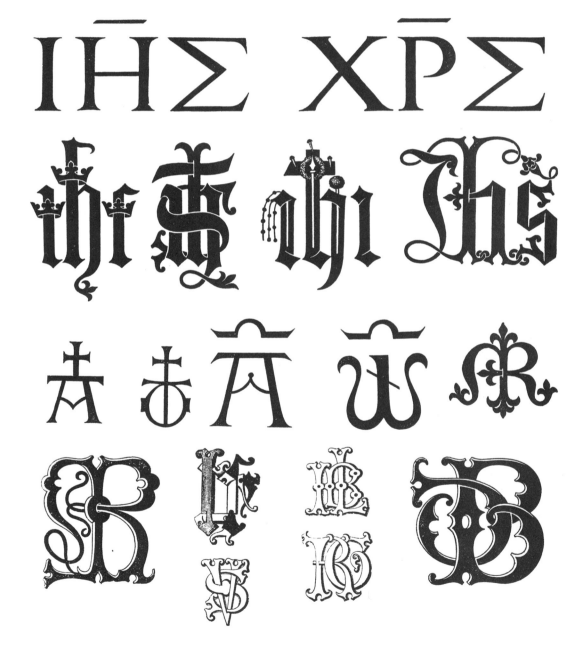

Sacred and other monograms, 13th–16th centuries.

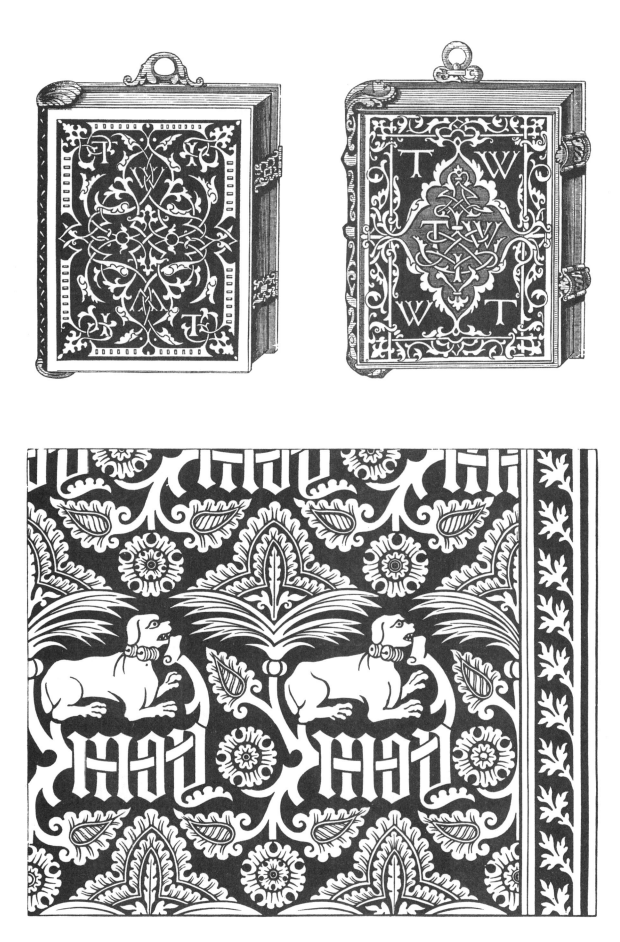

Book covers with monograms and motto, badge, etc.,
from a monumental brass, early 16th century.

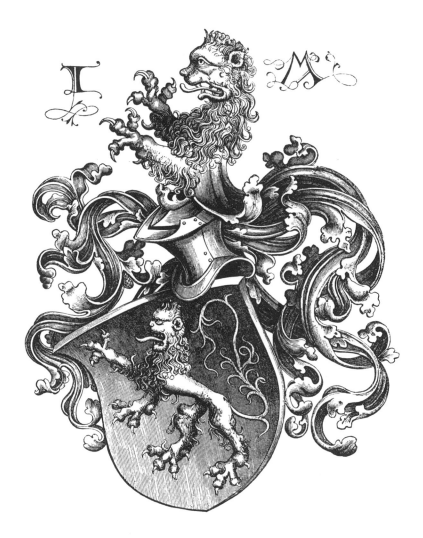

Heraldic devices, 16th century.